# Draw the Human Body

## ROY SPENCER

Series editors: David and Brenda Herbert

First published in 1981
New style of paperback binding 1997
By A&C Black Publishers Limited
38 Soho Square, London W1D 3HB
www.acblack.com

Reprinted 1999, 2004, 2007

ISBN-10: 0-7136-8307-4
ISBN-13: 978-0-7136-8307-3

Cover design by Emily Bornoff

Printed in China by WKT Company Limited

This book is produced using paper that is made from
wood grown in managed, sustainable forests. It is natural,
renewable and recyclable. The logging and manufacturing
processes conform to the environmental regulations
of the country of origin.

# Contents

# What to draw with and on

The idea of a drawing comes from observation; its execution comes from experience, and this can be greatly helped by your choice of materials. Always use those materials which make the techniques as easy as possible, and once you have chosen these, don't change to others if a particular drawing is not going well. The fault probably doesn't lie with the materials.

**Pencils** are the best all-purpose instrument. They are graded according to hardness and blackness. There are no rules which dictate what kind of pencil to use for what kind of drawing, but in general I recommend a soft pencil kept well sharpened, which can offer a wide range of shade from delicate grey to rich black. Always choose a paper that suits the instrument. The best surface for pencil is a fairly hard paper with a fine grain—good quality Ledger Bond ('cartridge' in the UK) for example. The softer the pencil, the softer the paper should be. Smooth paper has too little bite, rough paper is too bumpy.

**Charcoal,** which is generally associated with boldness, can also be used with subtleness and refinement—more like a soft pencil—by keeping it sharpened to a point.

**Conté crayons,** woodcased or in solid sticks, are available in various degrees of hardness. I recommend sticks, which have a better feel of the medium—lightness of touch is essential with Conté. Ingres paper, which is made in many colours, has a suitable surface. Most artists regard any but the most neutral colours as too stylish and old-fashioned.

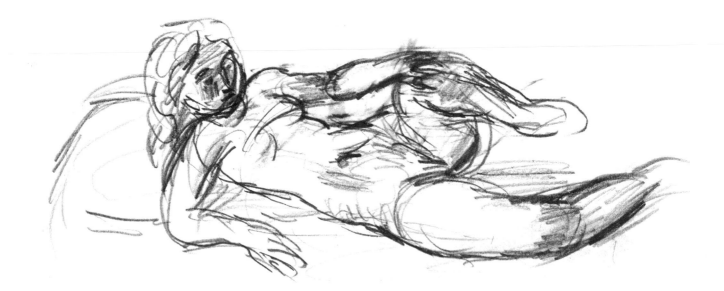

**Pen and wash** drawings require a bottle of black waterproof Indian Ink (or Pelikan Fount India), a pen of the Gillott 303 type (or a reed or quill), a pot of water and a medium-size watercolour brush. Indian Ink is normally rather thick in the bottle and is more usable when thinned with water—distilled or boiled. A sable brush is elastic and finely pointed. An ox and sable is cheaper and less alarmingly springy. The pen deals with lines in the drawing, the wash with areas; so the fine point of a sable brush may be exactly what you don't want.

**Ledger Bond or 'cartridge'** paper is good for pen and wash—especially a cheap, absorbent variety.

In general, a small drawing, whatever medium you use, requires a fine surface, whereas a rough paper may be more suitable for a large-scale drawing. But try to discover for yourself what materials serve you best.

# Making a start

Take a sheet of paper and see what exciting marks you can make on it with a pencil, pen or brush. More than anything else, the actual process of drawing—however unsuccessful to start with—will stimulate you to want to draw. Enjoy the materials you are using. Any drawing you make must have vitality, and it won't if you work at it too laboriously. It is easy to forget this when you are faced with a particularly difficult problem in figure drawing.

Drawings of the nude, as of any other subject, can take many different forms. They can be linear or tonal, very descriptive or almost abstract, large or small, detailed or broadly sketched, etc. Try various kinds. Compare the examples on these two pages.

There are really no rules in art; but the following guidelines may help you overcome some of the problems that face you at the beginning.

Draw small rather than large.

A pencil is the easiest tool to use.

The prospect of spoiling an expensive sheet of paper is inhibiting; so choose a reasonable cartridge paper to begin with.

Start your nude drawing with the head; it is the most familiar part of a figure and is therefore the most suitable part to establish first—as something 'fixed' against which you can measure and relate the rest of the drawing.

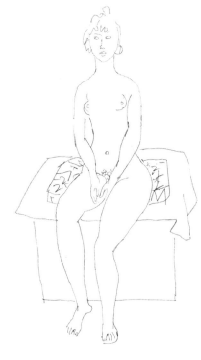

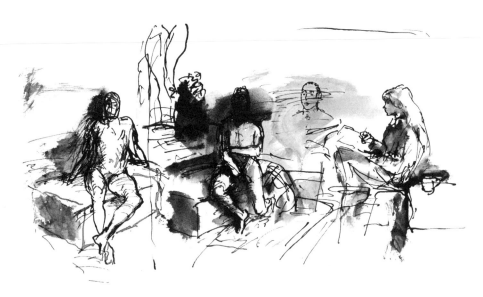

The human figure is the most interesting single object there is, and has been used as a motif in art throughout history. It has great expressive power and offers an extraordinary variety of forms.

The figure should be used, particularly at first, as a subject of study and to help your drawing generally; not as an attempt to produce works of art.

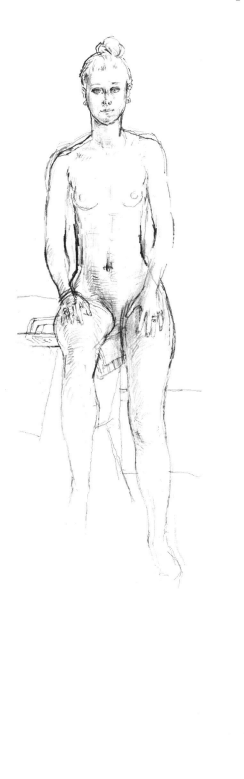

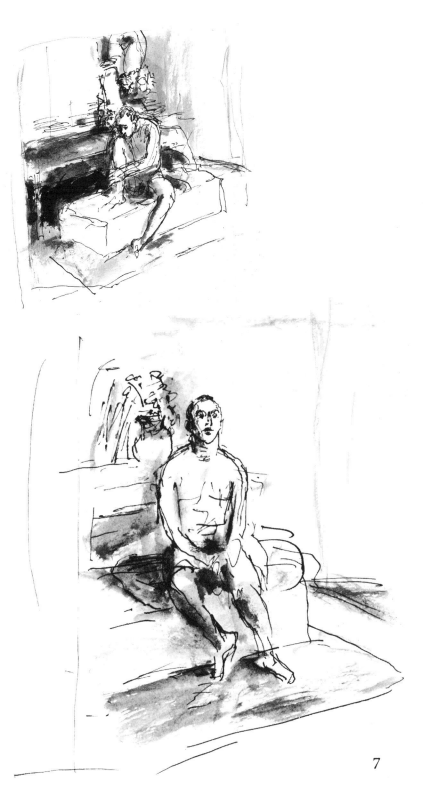

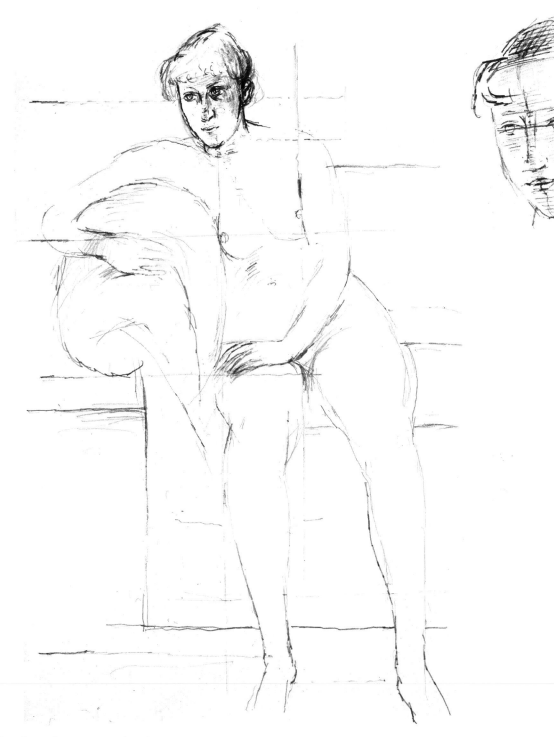

In this drawing, the head was the starting point. Try to
establish the features as accurately as possible. The separate
drawing on the right may help in understanding the head.
Judge the angle it leans from the horizontal and make the eyes
and mouth belong to the front plane. Treat the top and side as
planes at right angles to this front plane. The whole must be a
complete solid rather than just a mask. Hold your pencil at
arm's length towards the model, and measure the distance
from the chin to the nipple, comparing it with the size of the

head. The nipple is vertically below the left eye, and the same vertical runs through the tip of the fingers of the left hand. By careful observation you can discover other relationships which will help you to fix the position of other parts. The right hand is an example, but try to make it seem nearer to you than the shoulder. It is important to draw the arm of the sofa, because it both supports the figure and justifies the position of the figure's right hand and arm.

With a sitting or standing figure, the head is the highest part, so you can draw down the figure without your hand covering up what you have just done. Although the relationship between one part of the drawing to another is very important, the beginner will generally find it easier to start by drawing one part almost completely. In any case, don't sketch in the whole drawing first, since the result is bound to be entirely inaccurate and therefore no help at all. If you have any choice over where you draw from, a three-quarter view is easier than one from front or side.

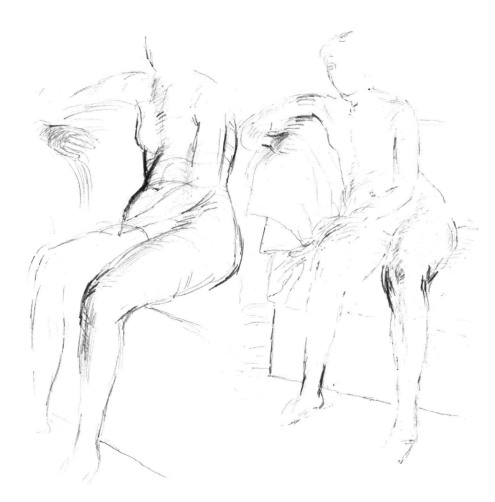

These drawings of different views of the same pose show that the problems are more exposed in a view which is less frontal. In a frontal view the parts that make up the figure are more easily identified, and the drawing looks like the subject long before the forms are really drawn.

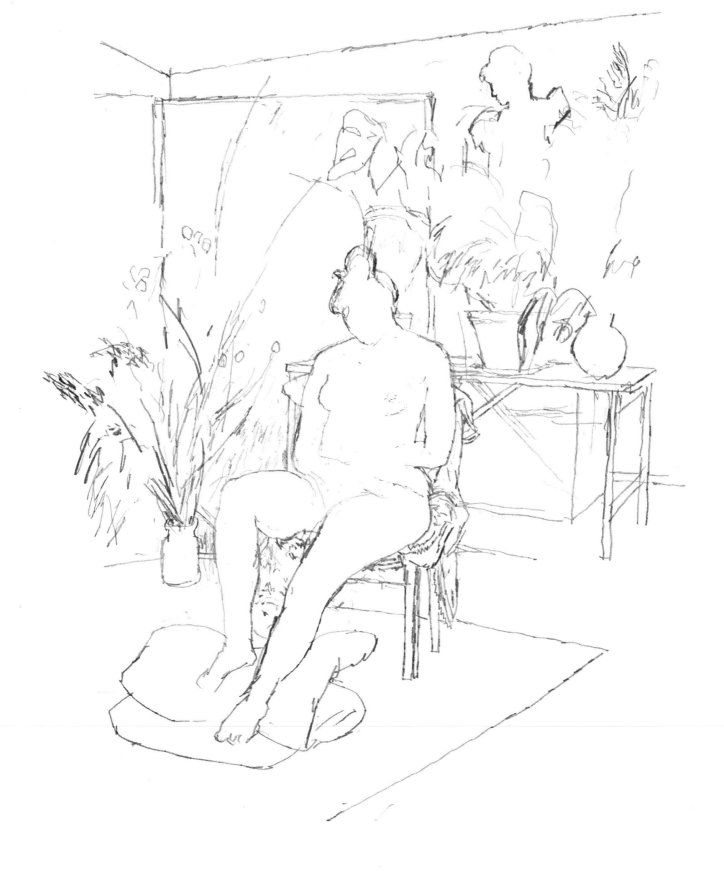

A figure needs a setting, however simple, or it will appear to **float** aimlessly in the middle of your sheet of paper. If you **relate** it to its surroundings, you will give it a sense of time **and place.** You will also find the proportions easier to **establish.** You can learn a lot from making drawings that **concentrate** on background, omitting almost all detail from the **figure.**

# Perspective

Much advice usually given on perspective suggests how you can convey the illusion of distance and three dimensions through the *lines* of your drawing. It is easier to think in terms of diminishing *planes*. If you try to represent the main *surfaces* of the figure with a feeling of direction and position in space, an impression of space will quickly emerge on the paper—and this is what perspective is about. Think of a cube and of how you would convey its three planes on paper, and try to see how this principle can be applied to your drawing of figures.

Once a sense of space is created on your paper by perspective (see right), any number of figures may be put in.

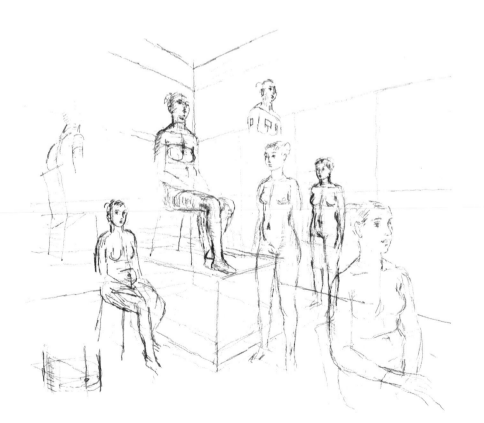

The figure here shows two planes at rightangles to each other—a front and a side plane. The raised position of the model forced me to convey this aspect of perspective. The sketch on the right is over-pedantic but elaborates the idea of the surfaces in perspective.

13

The distance between you and the model will greatly affect your view. The nearer you are, the steeper and more vital will be the perspective, since the subject will appear more solid and real.

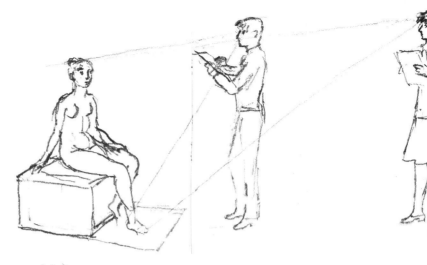

Of the two drawings below, the first was made about twenty feet from the model, and the second about half that distance.

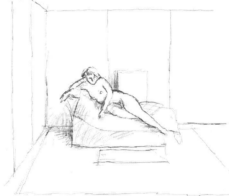

The drawing opposite was made very close to the model. Notice how steeply you look down onto the legs and feet.

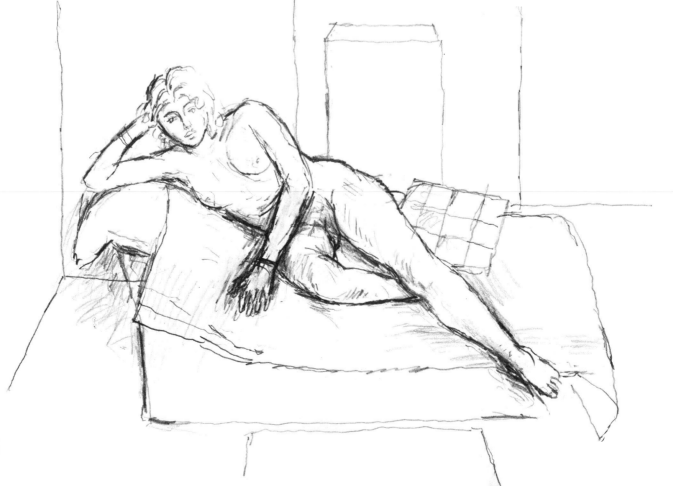

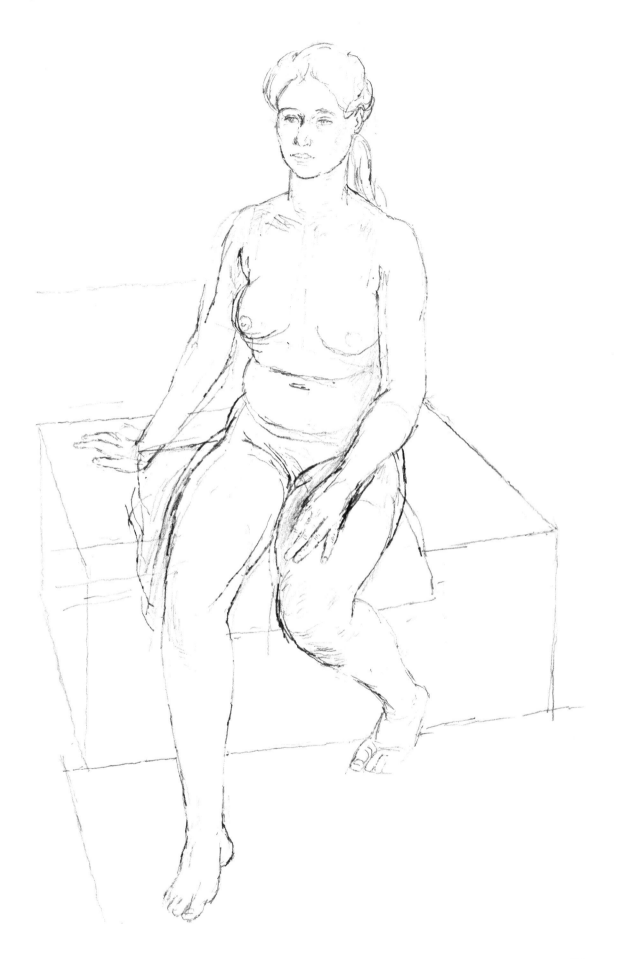

# Measuring

A plumb-line, held in front of you, will discover what parts of the body are on the same vertical as each other. But it is easier to discover a vertical than to judge an angle. With the figure on this page, you can find the position of each feature by first drawing a vertical line downwards through the left eye.

Against a ruler held at arm's length you can, for example, measure the distances from eye to chin to collarbone etc. Then you can measure distances to right and left of this 'centre' line and so make an accurate drawing of the whole figure.

Notice that your eye level is at the model's waist; you look up at the head and down at the feet. The torso and leg in the right of the drawing have approximately their natural length. Whereas, on the other side, the length from shoulder to leg is shorter because the figure is slightly tilted.

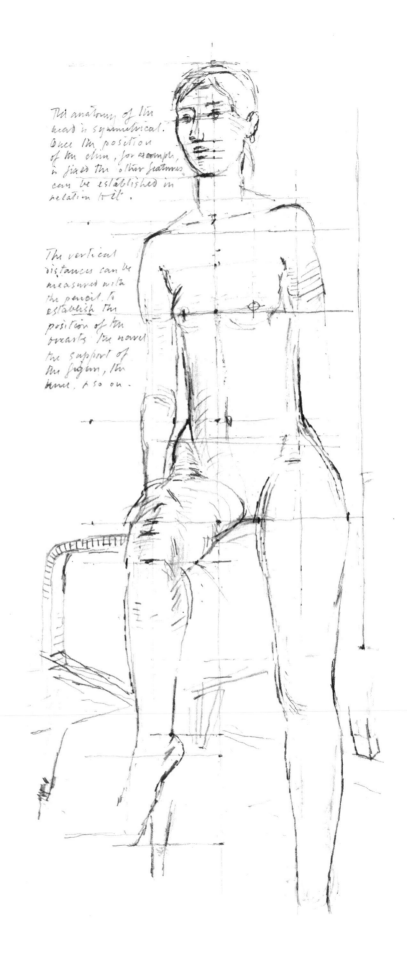

Remember that a figure is anatomically symmetrical and, although the symmetry is constantly disturbed by the pose, it must seem to be in balance. This one is supported by the right buttock, the left foot and (slightly) the right hand.

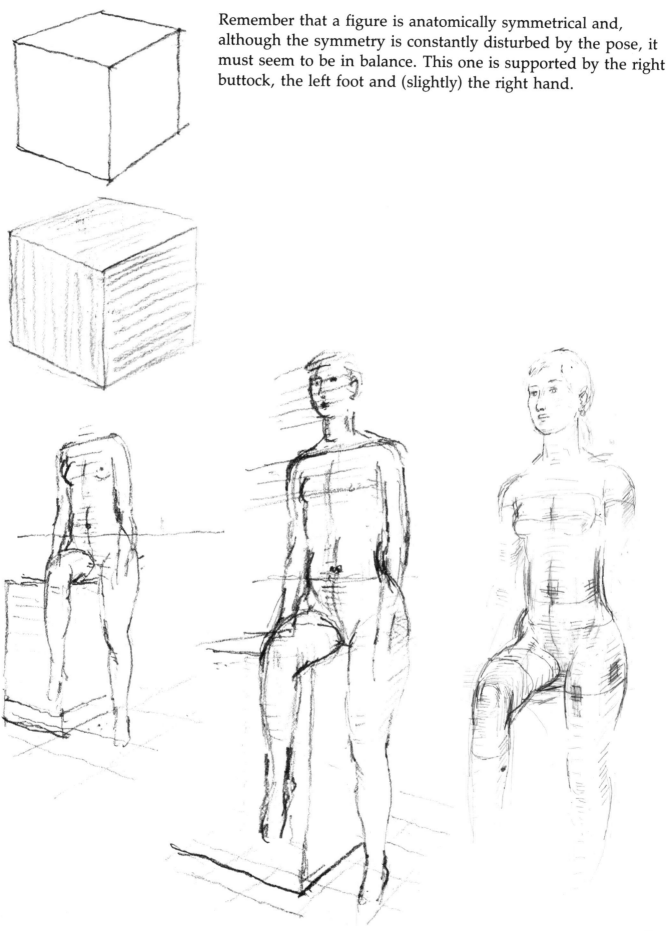

# Anatomy: general articulation

If you take something from a high shelf, bend down and put it on the floor, you will appreciate the amazing articulation of the human body. A general understanding of articulation is more valuable than a detailed knowledge of bones and muscles; but both are worthwhile, provided you realise that anatomical knowledge is no substitute for observation. It is useful merely because it helps to interpret what you see.

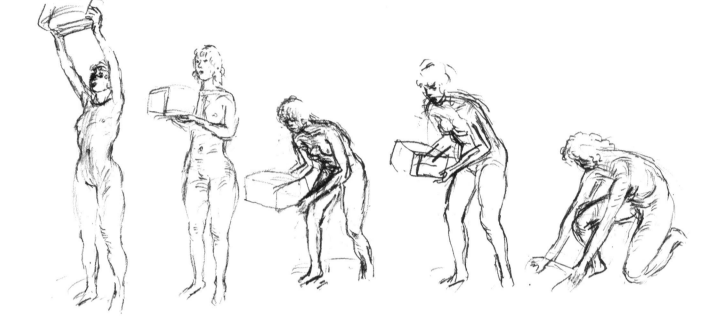

Throughout this book, I have not distinguished between the male and female figure—using female models almost always because, for psychological reasons, there have always been more nude females than males in art. The differences in a male and a female skeleton are small, the female's being lighter, her shoulders narrower and the angle and proportion of her pelvis different. The muscles are the same but differently developed—as indeed they are in people of the same sex. It is mostly the outer covering that distinguished the sexes, and usually the female anatomy is more concealed by a layer of fat.

Those parts of the skeleton that are near the surface need attention (see the three skeletons here), and it is helpful to understand the character of various joints. The whole of the spine is usually visible, but it is particularly noticeable just above the shoulders and where it joins the pelvis. The collarbones are always visible, and so too are the shoulder blades (back view) and lower ribs (front view) particularly when arms or shoulders are raised. The crests of the pelvis can be seen on either side of the stomach, and the head of the femur on a level with the pubis (the joint itself is further in). The bones at elbow, wrist, knee and ankle are always visible.

The drawings below show that knowledge of the lengths of various bones can help to get proportions right.

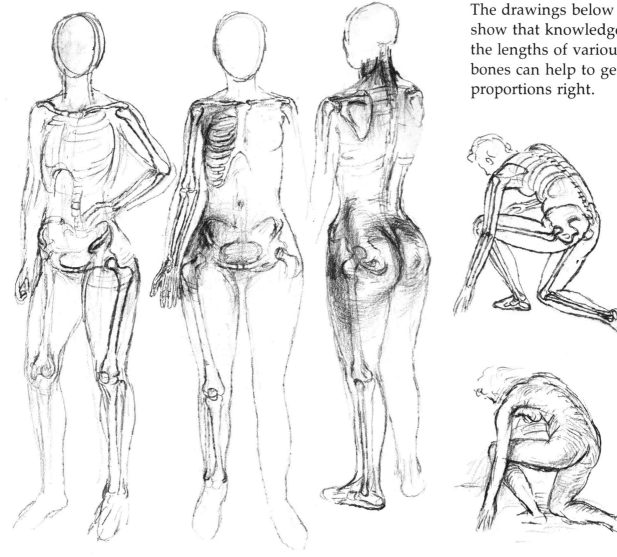

Sterno-Mastoid
Clavicle
Deltoid
Pectoralis major
Rectus Abdominalis
Obliquus Abdominus
Linea Alba
Crest of Ilium
Abductors of Thigh
Sartorius
Vastus Medialis
Sartorius Tendon
Gastrocnemius
Soleus
Extensor Retinacula

Deltoid
Biceps
Triceps
Pronator Teres
Brachioradialis
Flexor Carpi Radialis
Flexor Carpi Ulnaris
Tensor Fascia Lata
Rectus Femorus
Sartorius
Vastus Medialis
Vastus Lateralis
Patella
Sartorius Tendon
Tibialis anterior
Gastrocnemius
Soleus
Tibia

20

# Anatomy: detail

These two drawings show the main surface features of the human anatomy—in considerable detail—in a way that many artists of the past found essential to their work. Some knowledge of the larger anatomical forms can help to understand the figure in a particular pose—and can help too when you are drawing people when they are not nude. But remember the information is an aid to observation, not an aim in itself.

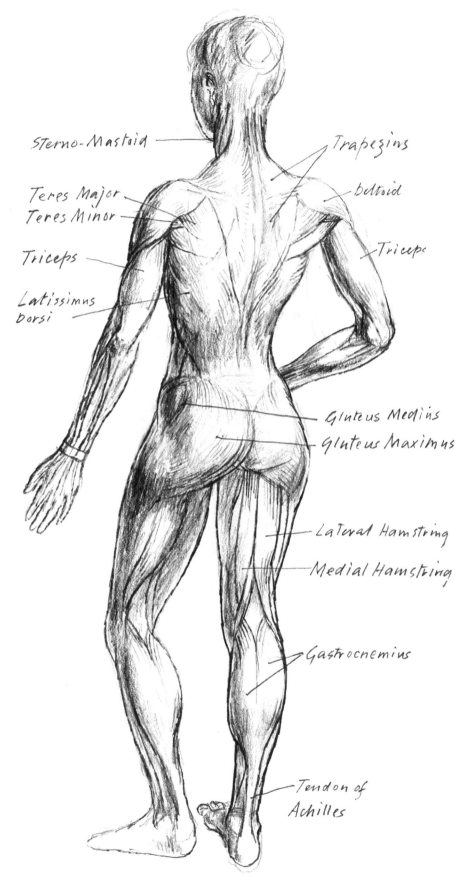

Sterno-Mastoid

Teres Major
Teres Minor

Triceps

Latissimus
Dorsi

Trapezius

Deltoid

Triceps

Gluteus Medius
Gluteus Maximus

Lateral Hamstring

Medial Hamstring

Gastrocnemius

Tendon of
Achilles

# Standing

Get your model to stand symmetrically with his or her weight evenly distributed on both feet. Hold a plumb line in front of the centre of the figure. Now get the model to move the weight from one foot to another, turn the body etc without moving the feet. Against the plumb line, you will see how the position of the head and every other part changes, as the figure adjusts to keep the whole body in balance. Note also how the tensions in the anatomy change. Extend this exercise to make drawings of many poses with the position of the feet unchanged.

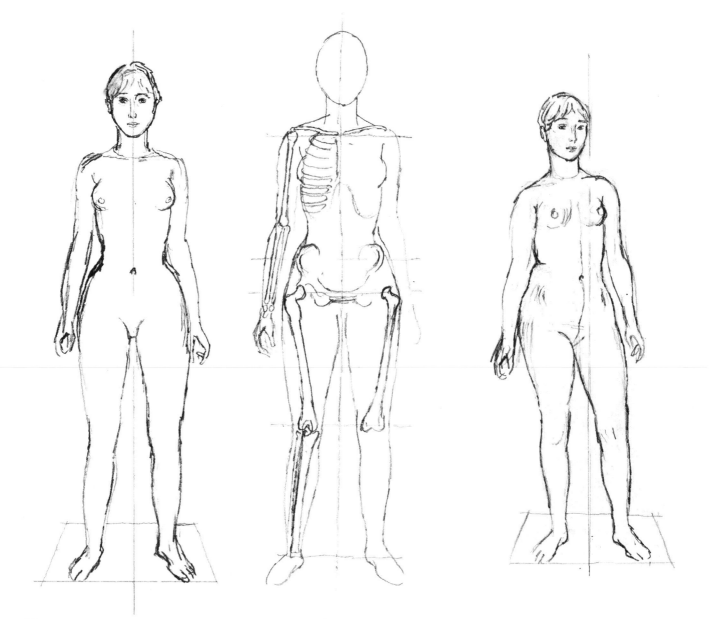

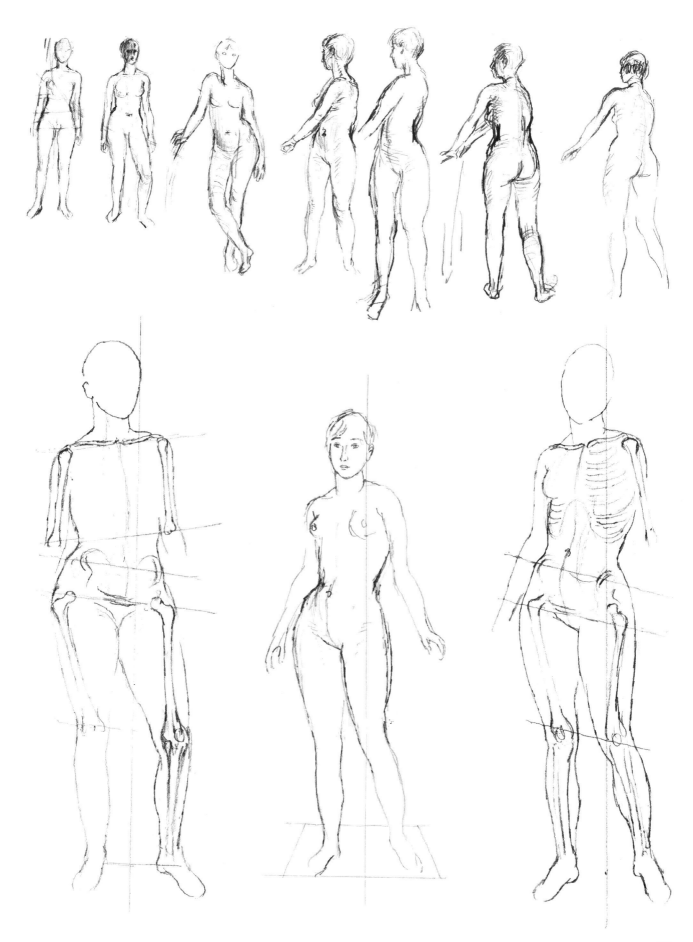

23

Make comparative drawings of the same pose from different angles.

Then try a standing pose in which the figure is partly supported by a hand and notice how the balance of the figure is altered. It is important to observe which parts of the body are supporting or in tension, and which are relaxed and giving way to gravity.

Drawing is understanding as well as seeing. It should be more than merely copying what you see before you. Your observation must be intense and purposeful always, and what you put on paper as a result must be equally purposeful.

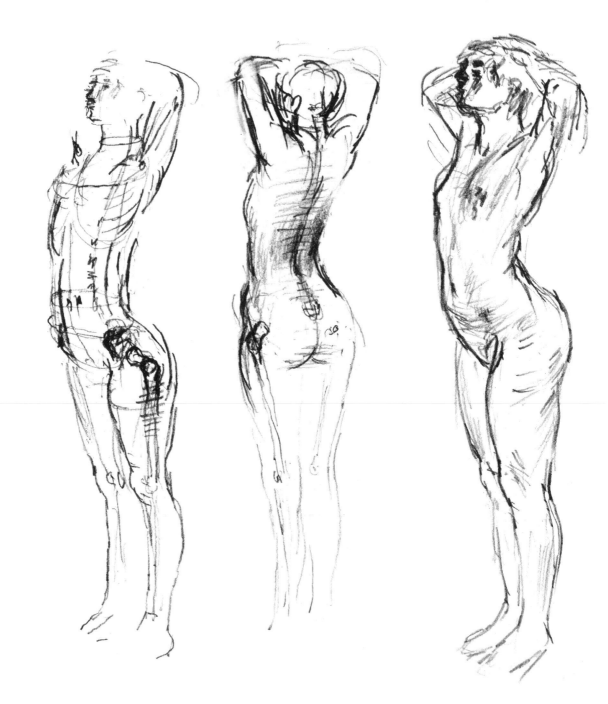

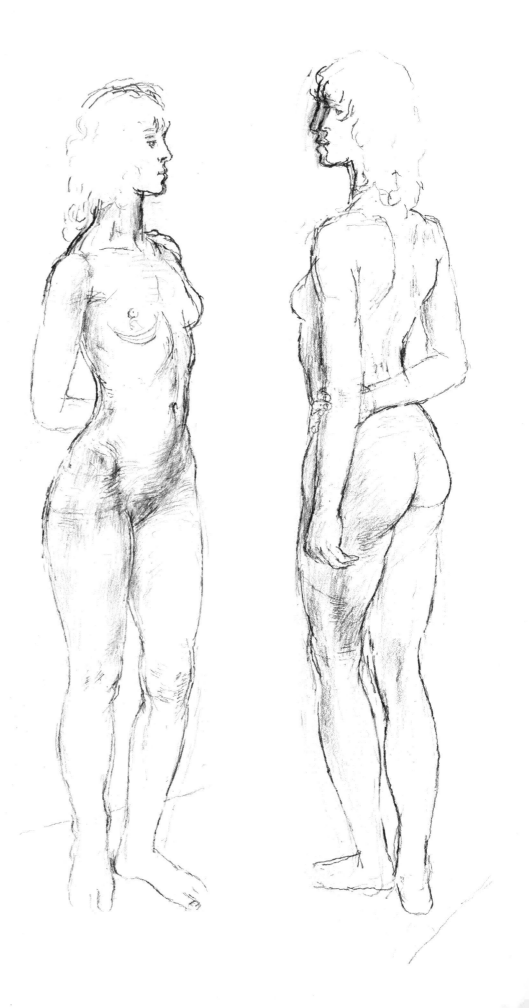

# The shoulder

Anatomically the shoulder is complex. It can move up and down, forwards and backwards; and the arm can move in a complete circle—which is very different from the limited movement the leg can make from the hip. The shoulder's only fixed connection is through the collarbone, which is joined by cartilage to the breast bone. Examine a skeleton if you can or explore your own shoulder to see how it works. Using a model, draw the shoulder with the arm in various positions, as I have here.

In back views you will find the scapula fairly easily. Notice its mobility, its position varying with the position of the arm.

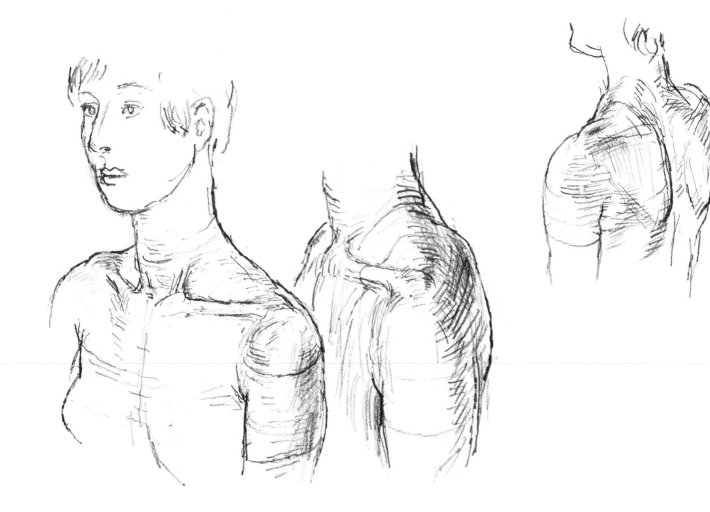

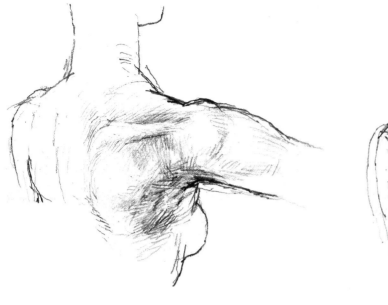

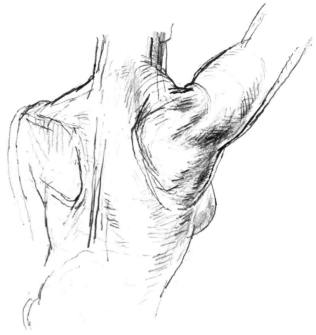

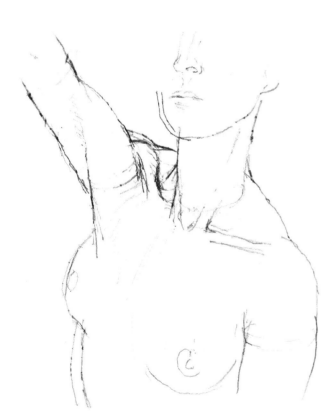

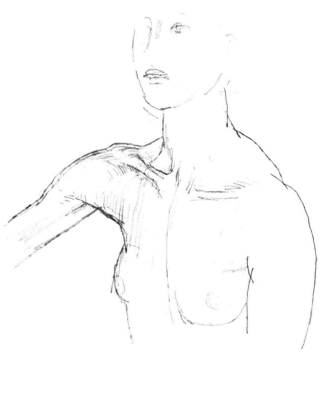

# The arm

An arm in a position of support is very different in character from a hanging, relaxed arm. It is locked, straight at the elbow, with the shoulder usually high and the collarbone conspicuous.

Rotating the hand without moving the upper arm is made possible by the presence of two parallel bones (radius and ulna) joining the wrist to the elbow; the radius being on the same side as the thumb.

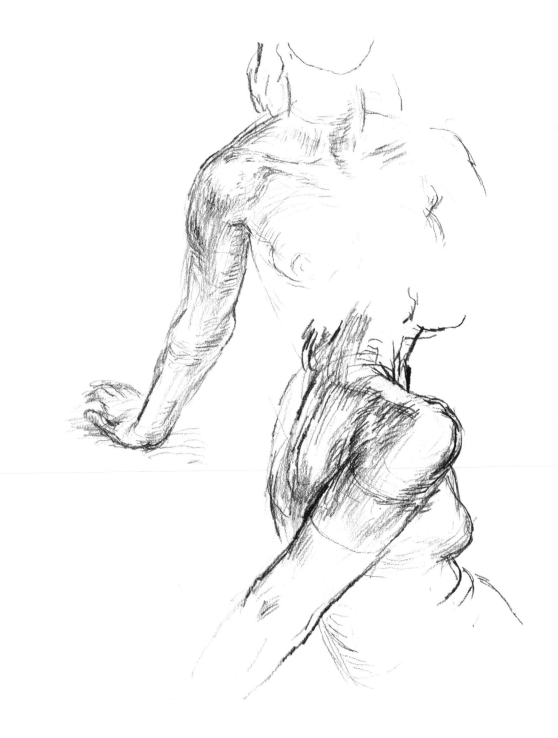

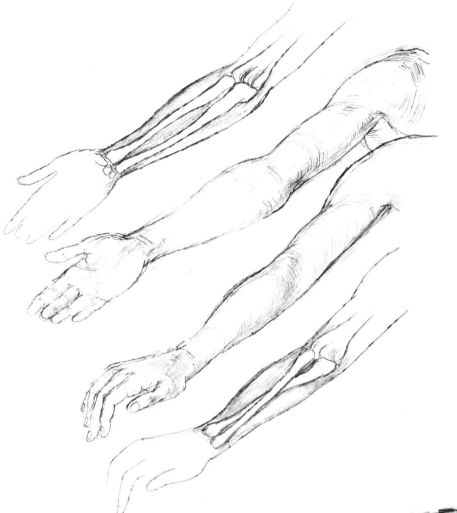

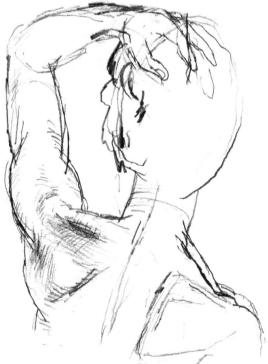

# The leg and pelvis

The sartorius is the long muscle which goes from the iliac crest across the thigh to the inside of the knee. The division it makes can always be seen, leaving a familiar triangular shape on the inside of the thigh which is known as Scarpa's triangle. The anatomical and diagramatical sketches which accompany the other drawings here help to explain the structure of the legs and pelvis.

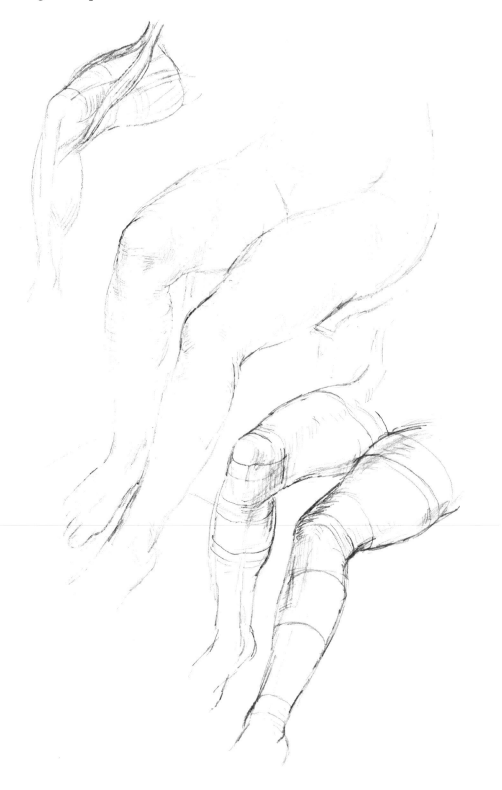

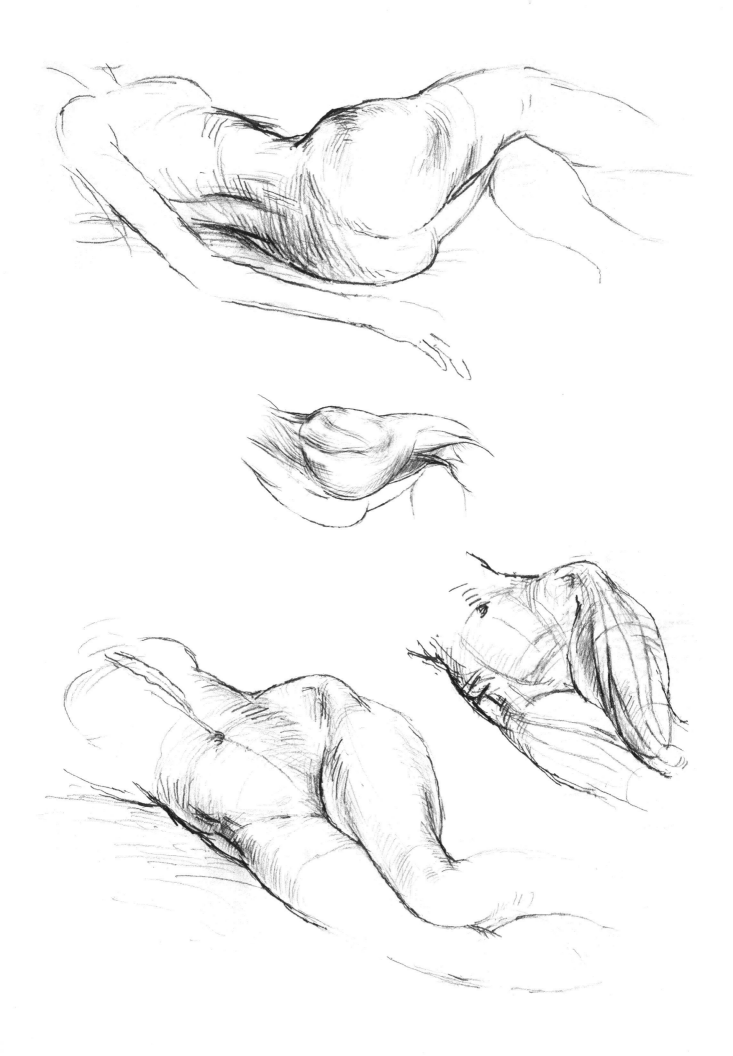

# The head

Head and hands are the most expressive parts of the human body. The pose of the head often suggests the pose of the whole body and, with standing or seated figures at least, it is usually best to start with the head. Unlike many parts of the body, it has a fixed shape and size and so provides a constant to which other parts can be related.

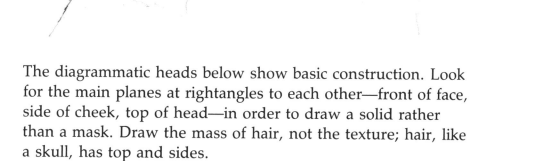

The diagrammatic heads below show basic construction. Look for the main planes at rightangles to each other—front of face, side of cheek, top of head—in order to draw a solid rather than a mask. Draw the mass of hair, not the texture; hair, like a skull, has top and sides.

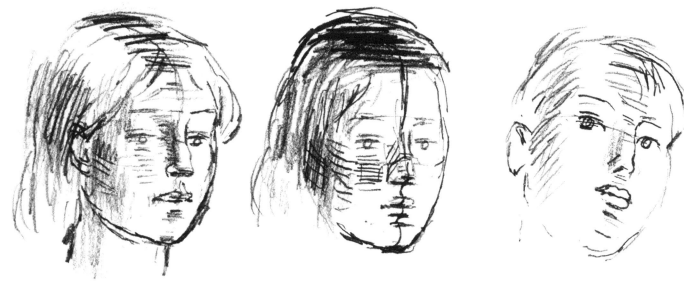

# Fore-
# shortening

Foreshortening is a matter of drawing receding planes. It comes into any figure drawing to some extent, but does not always show itself as a problem. It is most difficult, obviously, when you try to draw a lying or reclining figure from one end. Careful measurement will help to make an accurate drawing. Plot the features of the head and body; then draw in the planes that connect them.

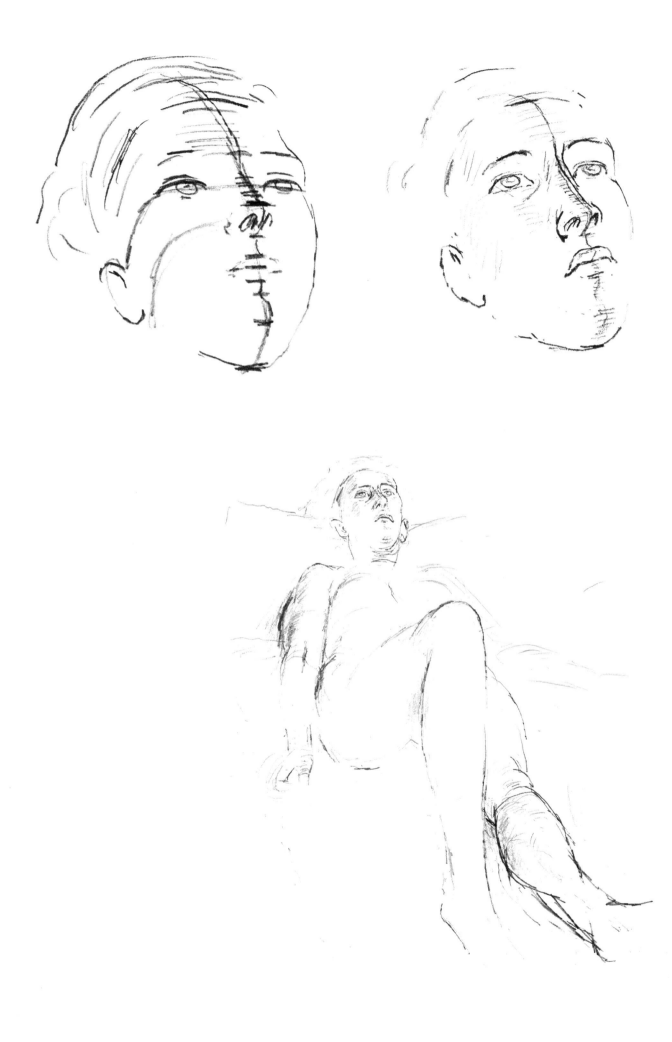

# Lying

In a lying pose, the soft forms of the body collapse; the pelvis becomes very conspicuous and the soft waist small and flattened. Many parts are foreshortened, in particular the head. Always draw the supporting surface; if it has a strong, clear shape, draw it first and fit the figure onto it, particularly if the figure is lying at an angle.

In the bottom drawing right, notice how the soft forms of the female are distorted by gravity from their normal anatomical symmetry.

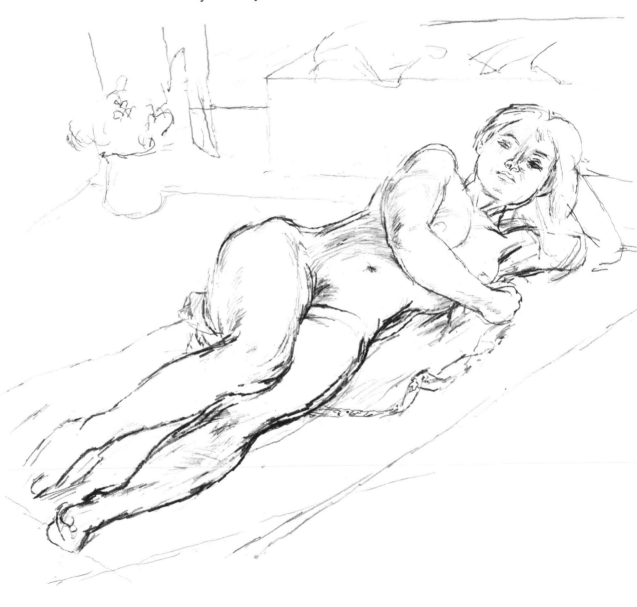

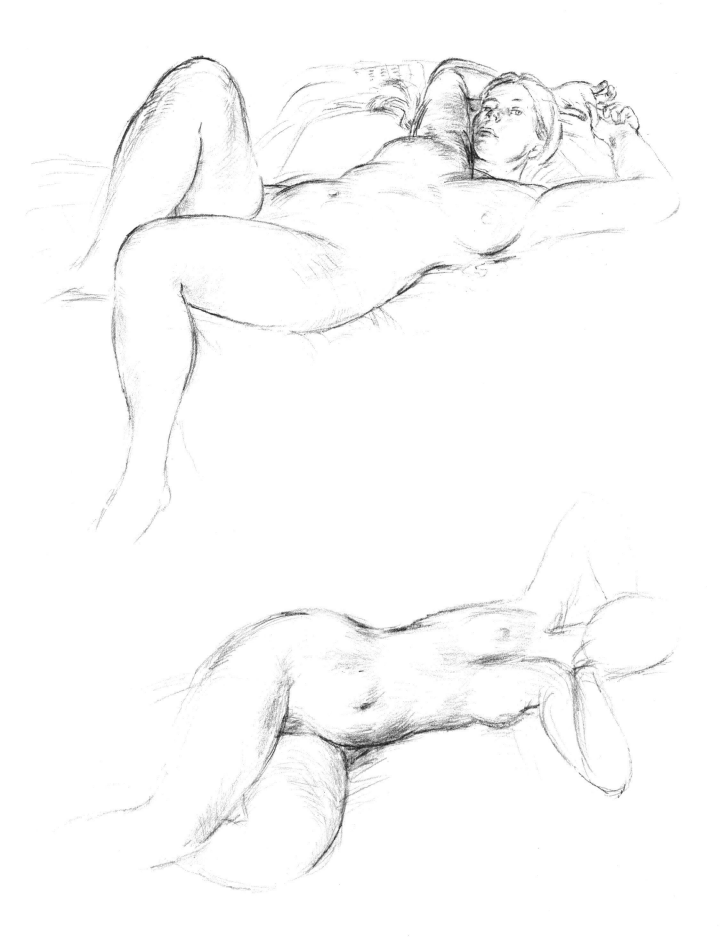

# Sitting

Accuracy is less critical with a seated than with a standing figure, since the same exactitude of balance is not required. But try to make your drawing *look* right. Make several studies of the same pose from different viewpoints; a drawing from the side will increase your understanding of the front view and *vice versa*.

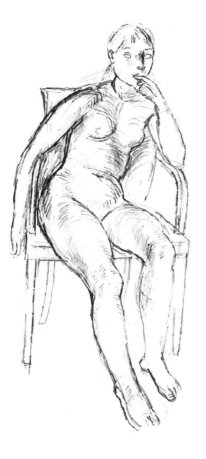

# Drawing from memory

Many artists of the past and illustrators today learned the value of being able to do this. Memory of the body's articulation and of various poses are what is necessary. Memorising outlines is useless, since you are coping with mass and space. To start with, draw a box from memory—which is not difficult for anyone who understands its 3-dimensional shape and the planes that make it. Then draw a chair from the same ¾ view which was needed to show the box's shape. Finally, sit a figure on the chair.

It is helpful, first, to observe and sketch a model with a chair from several points of view in order to understand the pose and construction of your drawing. Make her stand, turn round, put a foot on the chair etc.

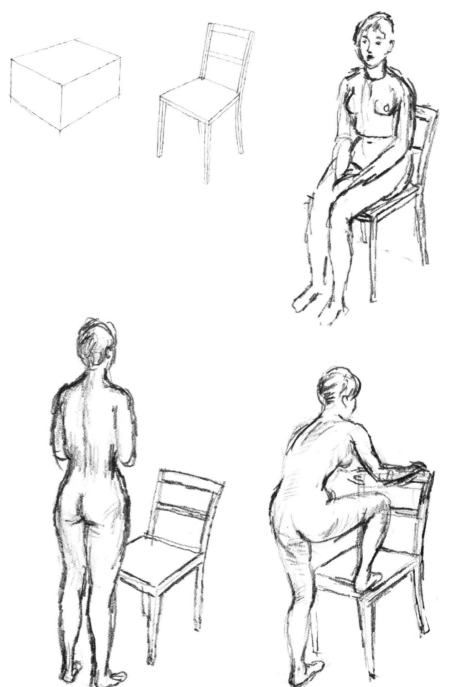

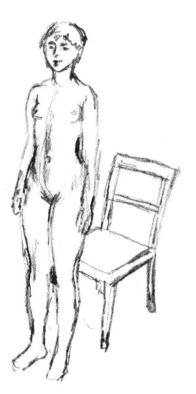

# Line drawing

When making a linear drawing, look at the shape between the outlines not at the outlines themselves. The function of the lines on the paper is to suggest the volume which they enclose. Make sure the line has a feeling of direction and tension and that it relates to other lines in a way that implies the solid between them. If you draw a small freehand circle, and then another circle to suggest a ball, you will see what a line must do in a linear drawing.

Some poses lend themselves to line drawing more than others. In this one, the pose and front plane of the head is created by the position and drawing of the features.

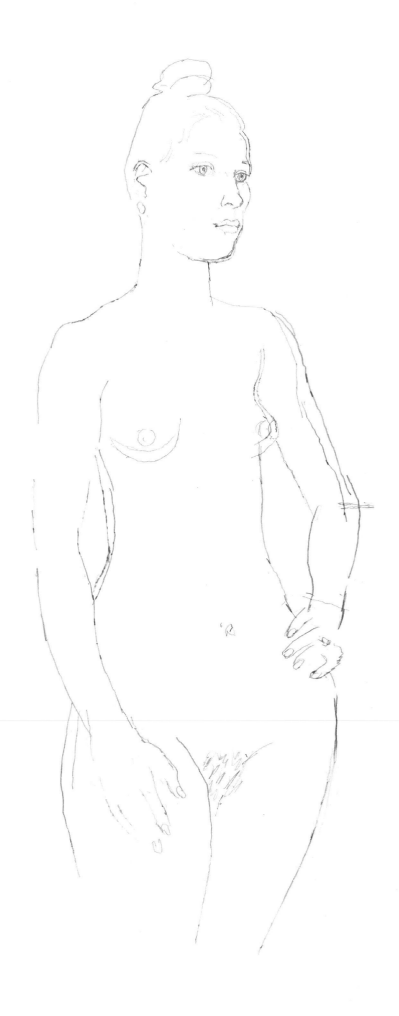

40

The features of the face and torso make the front plane of this figure and imply its direction in space. The relationship of feet, shoes and chair legs imply the floor and the angle from which it is viewed.

# Pen and pen-and-wash drawing

The firm and elastic Gillot 303 is a good nib to use. Obviously the ink must be waterproof, and I recommend neutral colours such as black or sepia, on white (also neutral) paper. The pen drawing and the wash should be done together, not separately, like two instrumentalists playing a duet. Do the fine work with the pen and put the wash on in areas, presenting the subject in broad areas of light and dark. It is wise to place your model where there is some fairly conspicuous light and shade.

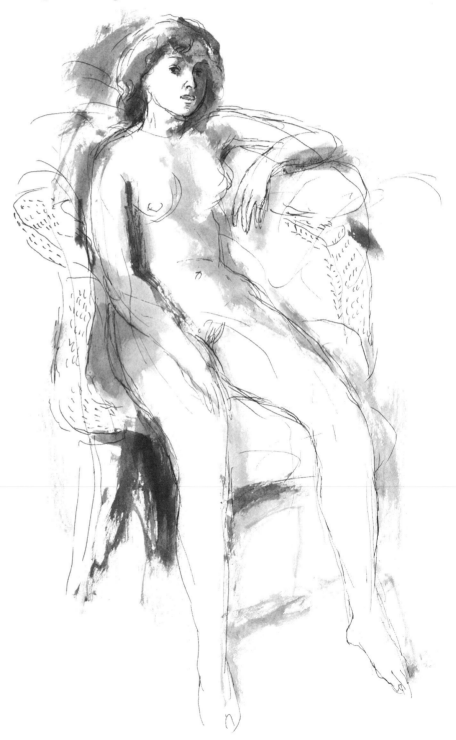

A pen normally draws a fine line but, whether you use this or make a thicker one by pressing hard, draw vigorously to grasp the solid form. Indian ink is usually too thick and quickly clogs the pen. But if you dilute it—with distilled water—you can draw broadly without the dark areas looking like black enamel. In the pen drawing right, the planes and tone are indicated by cross-hatching.

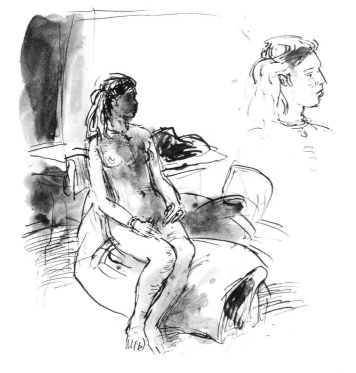

# The figure in its setting

Far more paintings have been made from drawings than have ever been done directly from the subject. You may wish to paint the nude from a drawing yourself, so get as much information about the surrounding of the figure as of the figure itself. As suggested earlier in this book, it is generally speaking a good idea to relate the nude to an environment; but this idea may be extended so that you have, for example, a picture of a room with a figure in it.

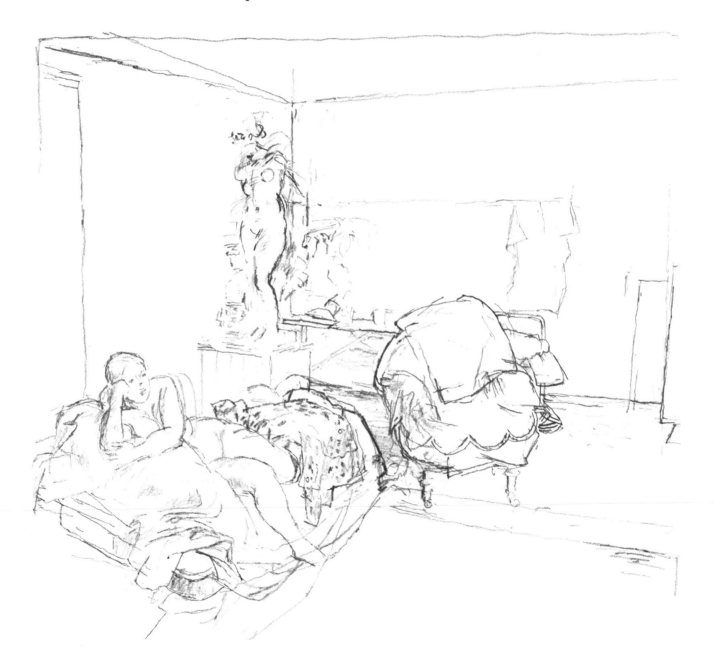

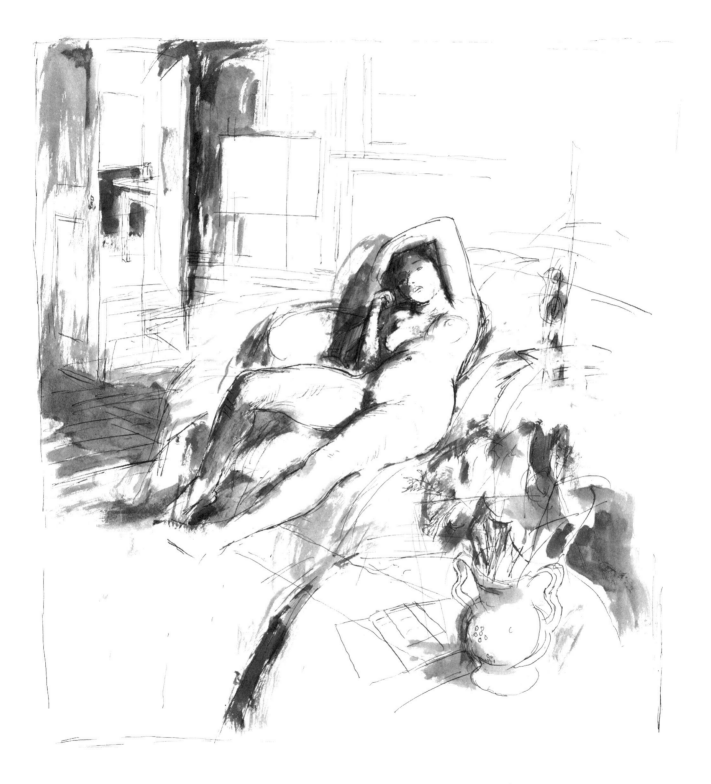

# Composition

Design is important always. Before you draw, think about how your subject—figure and surroundings—will compose on the paper. Study the scene before you and decide on the boundaries of your picture. It may help to look at it through a rectangular hole cut out of a piece of card to the same proportions as your drawing paper.

Compositions often exist in terms of horizontals and verticals. In the sketch below the basic composition features are the vertical objects on the left which go from top to bottom, the horizontal couch and figure stretching to the right-hand boundary, and the vertical objects behind the figure.

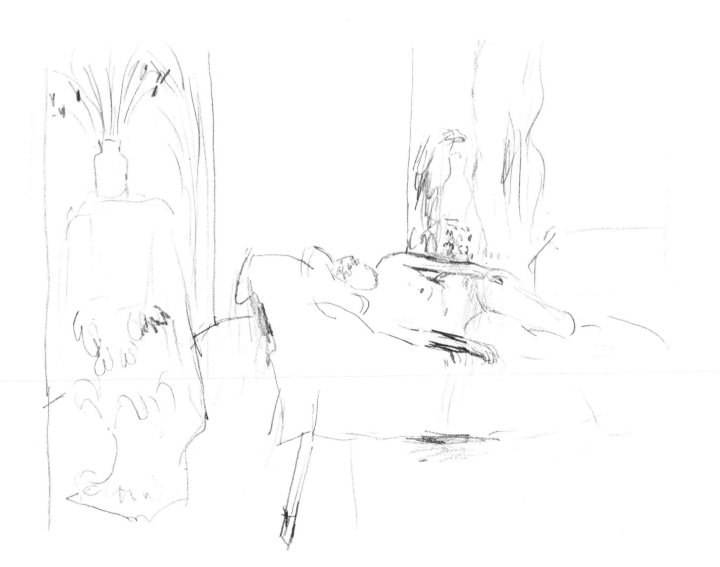

In the drawing below, figure, plants, sofa and other objects have become fused together into a unified concept of form and light. Always try to draw links from one object in a drawing to another in order to bring unity into a composition.

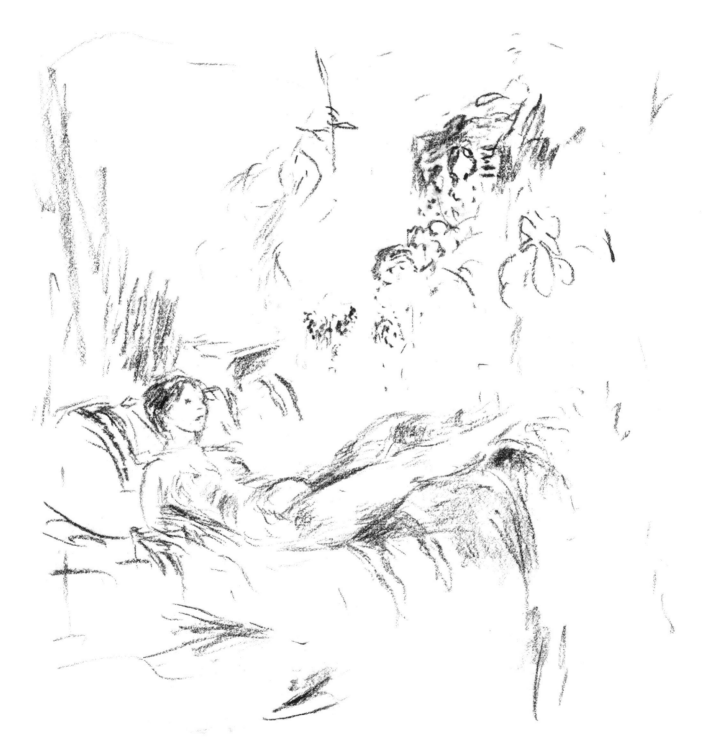

# Sketchbook

Art has its roots in observation. Cultivate this idea whenever possible by using a sketchbook. The model is equally interesting when she is resting or moving about between set poses. Make use of any opportunity to increase your understanding and extend your drawing ability.

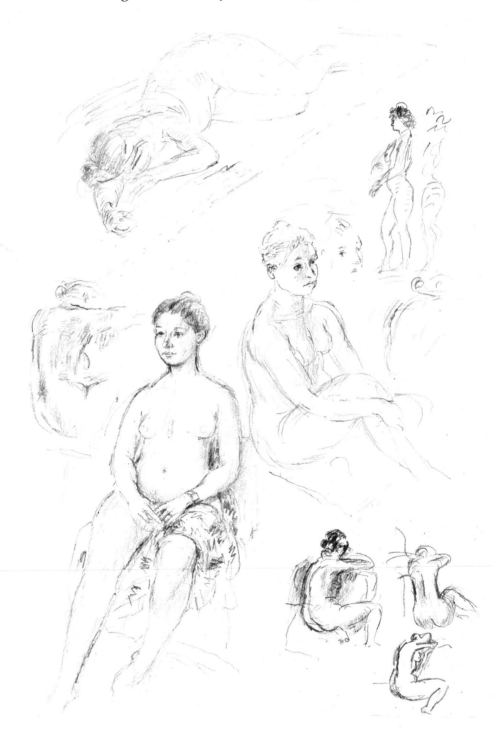